Art
Therapy
doodle & dream

Art Therapy: doodle & dream

First published in the United Kingdom in 2015 by
Bell & Mackenzie Publishing Limited

Copyright © Bell & Mackenzie Publishing Limited 2015

ISBN: 978-1-910771-13-6

A CIP catalogue record of this book is available from the British Library

Created by Christina Rose

Contributors: Goldenarts/shutterstock, Amovitania/shutterstock, karakotsya/shutterstock, romawka/shutterstock, Julia Snegireva/shutterstock, Igor Sorokin/shutterstock, Snezh/shutterstock, Polina Katritch/shutterstock, Maryna S/shutterstock, Kollibri/shutterstock, Katyau/shutterstock, bekulnis/shutterstock, New Line/shutterstock, Evgeniya Alekseeva/shutterstock, Lunarus/shutterstock, Vlada Young/shutterstock, Anita K/shutterstock, Fears/shutterstock, SPYDER/shutterstock, Elena Medvedeva/shutterstock, maljuk/shutterstock.

www.bellmackenzie.com

This book belongs to..........

Dreams are today's answers to tomorrow's questions.

Edgar Cayce

All human beings are also dream beings. Dreaming ties all mankind together.

Jack Kerouac

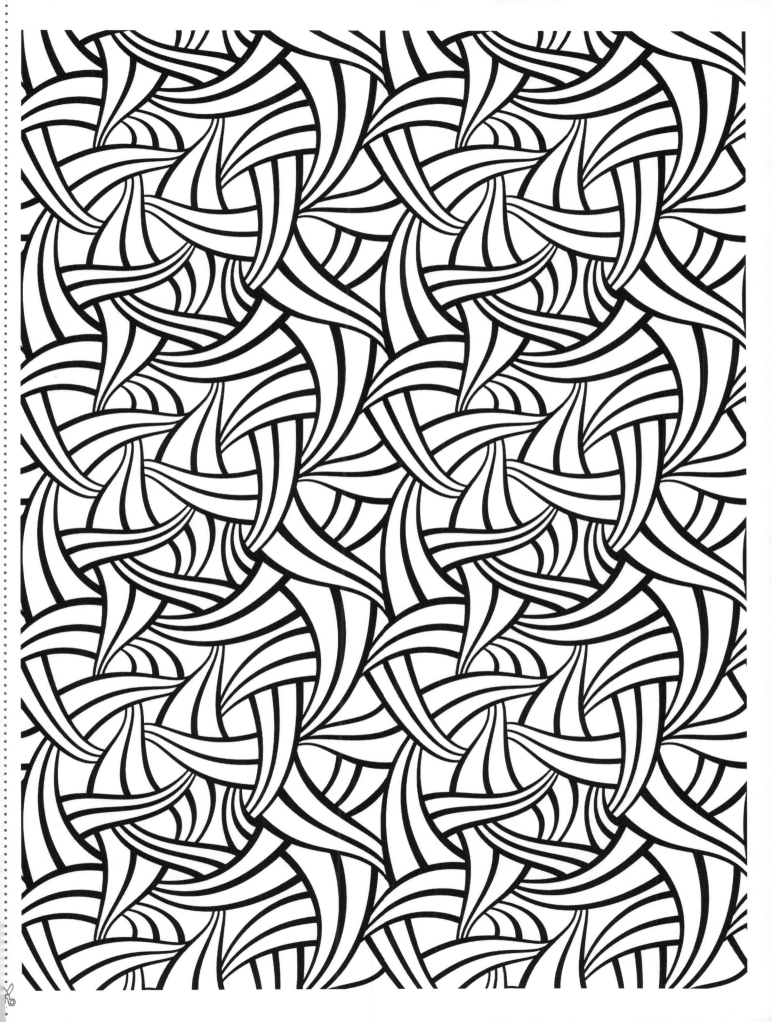

Dreams must be heeded and accepted. For a great many of them come true.

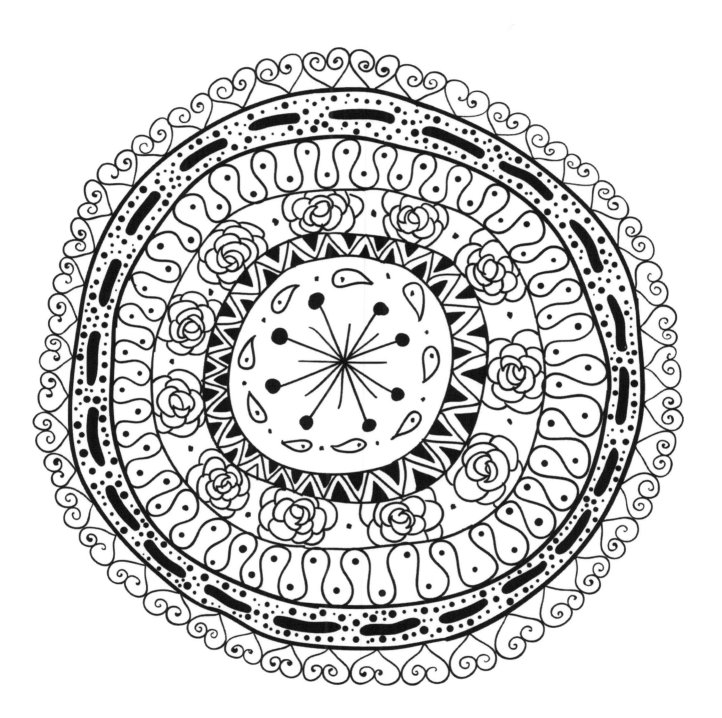

L

iving in dreams of yesterday, we find ourselves still dreaming of impossible future conquests.

Charles Lindbergh

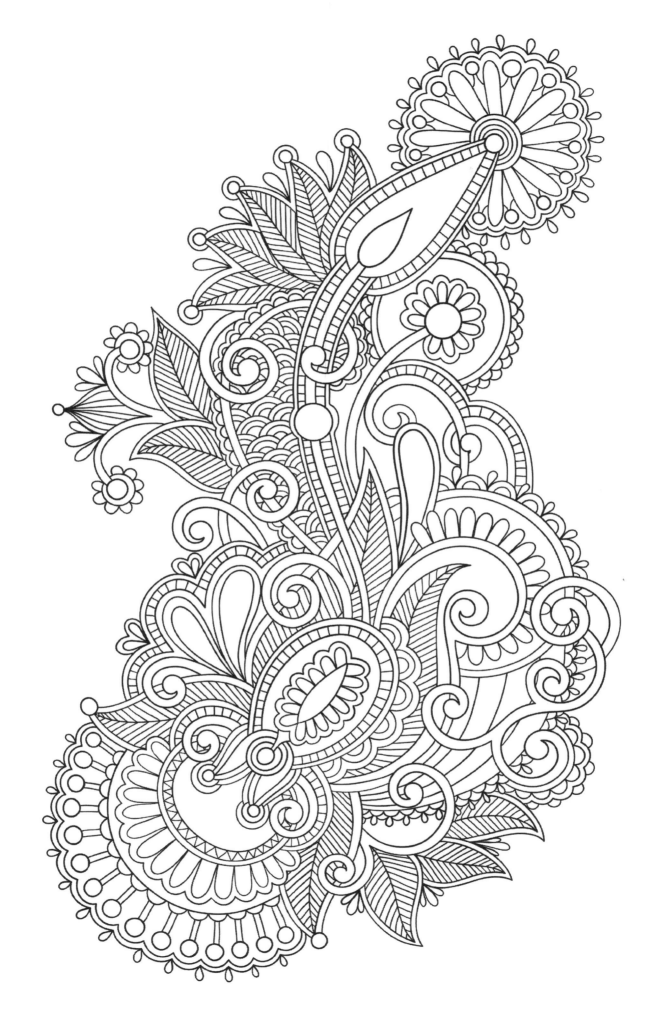

Tread softly because you tread on my dreams.

William Butler Yeat

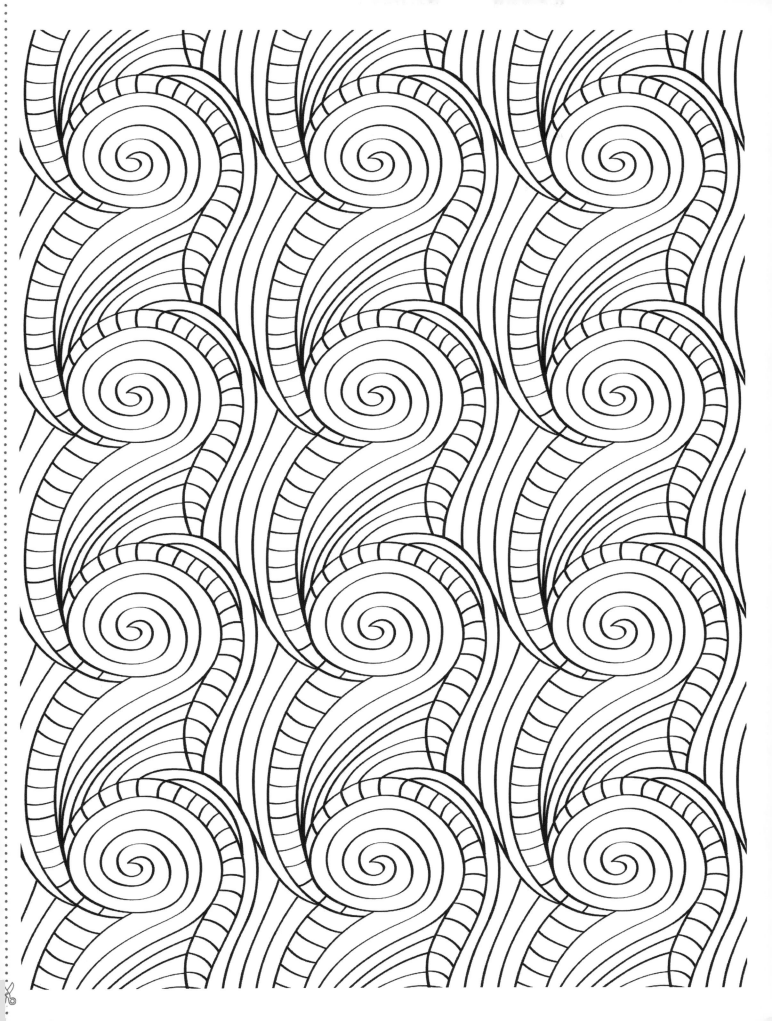

The world needs dreamers and the world needs doers. But above all, the world needs dreamers who do.

Sarah Ban Breathnach

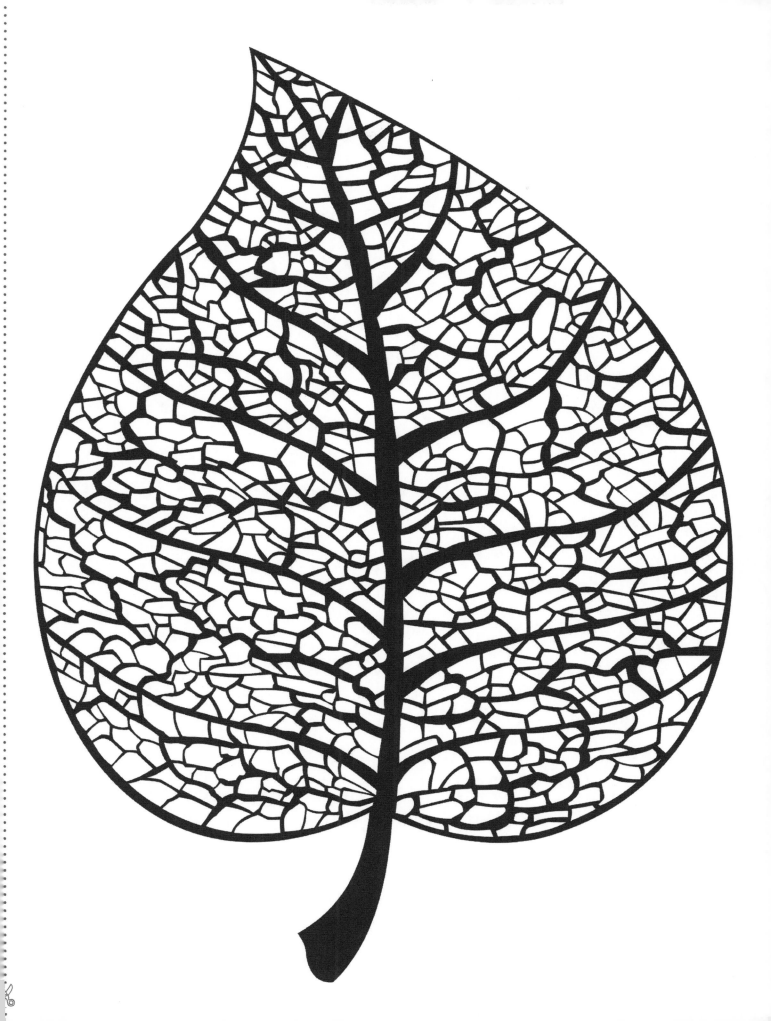

A

ll our dreams can come true, if we have the courage to pursue them.

Walt Disne

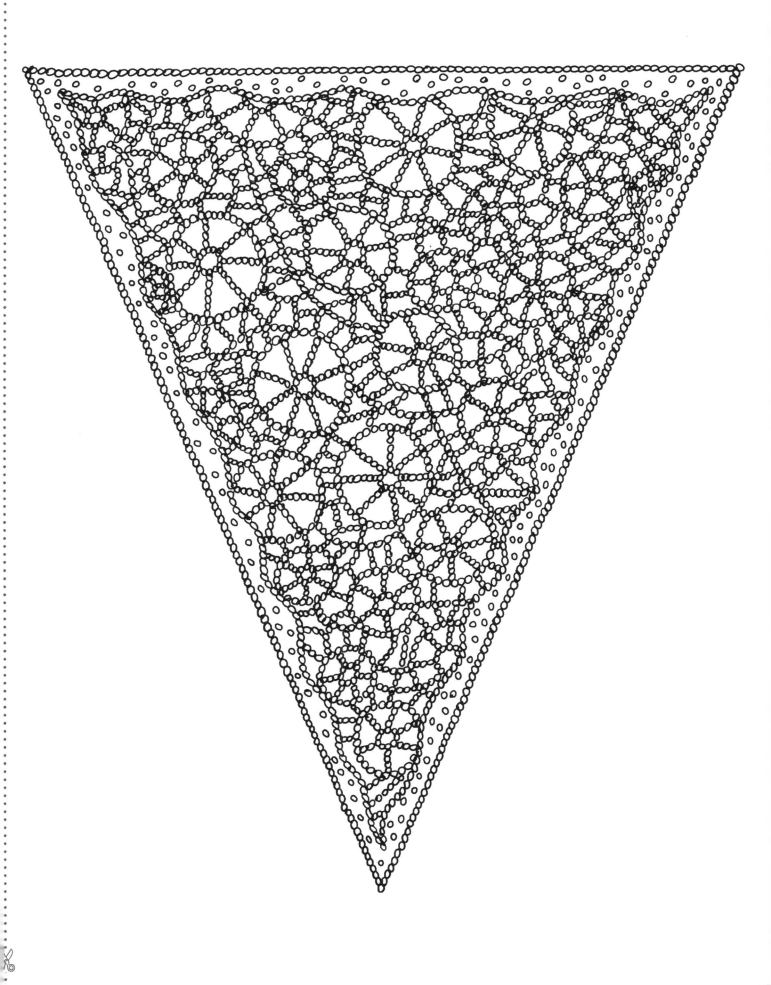

Every great dream begins with a dreamer. Always remember, you have within you the strength, the patience, and the passion to reach for the stars to change the world.

Harriet Tubman

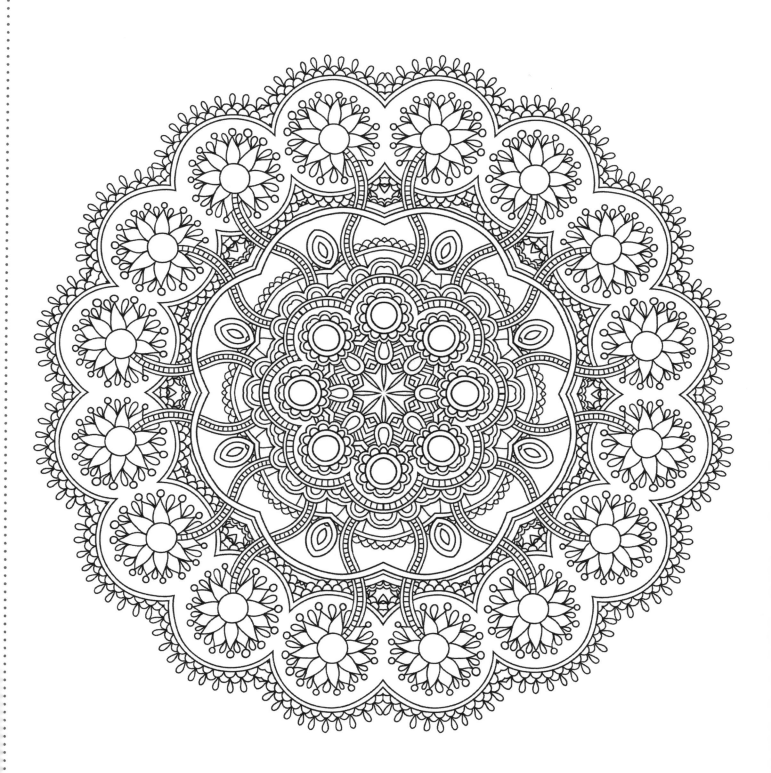

D

eep into that darkness peering, long I stood there, wondering, fearing, doubting, dreaming dreams no mortal ever dared to dream before.

Edgar Allan Poe

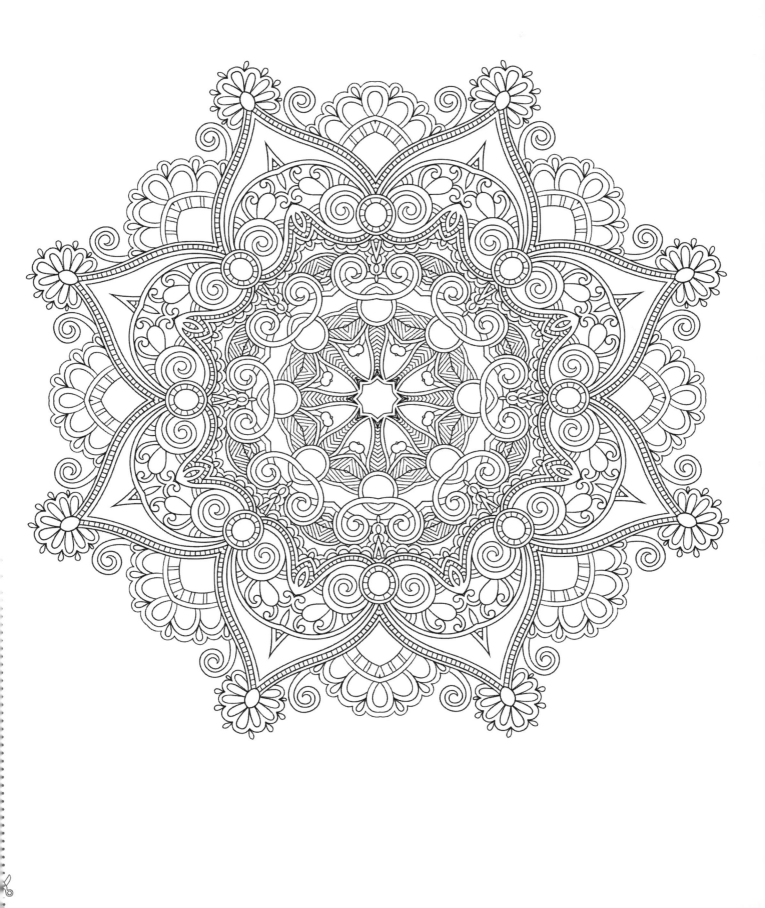

You have to dream before your dreams can come true.

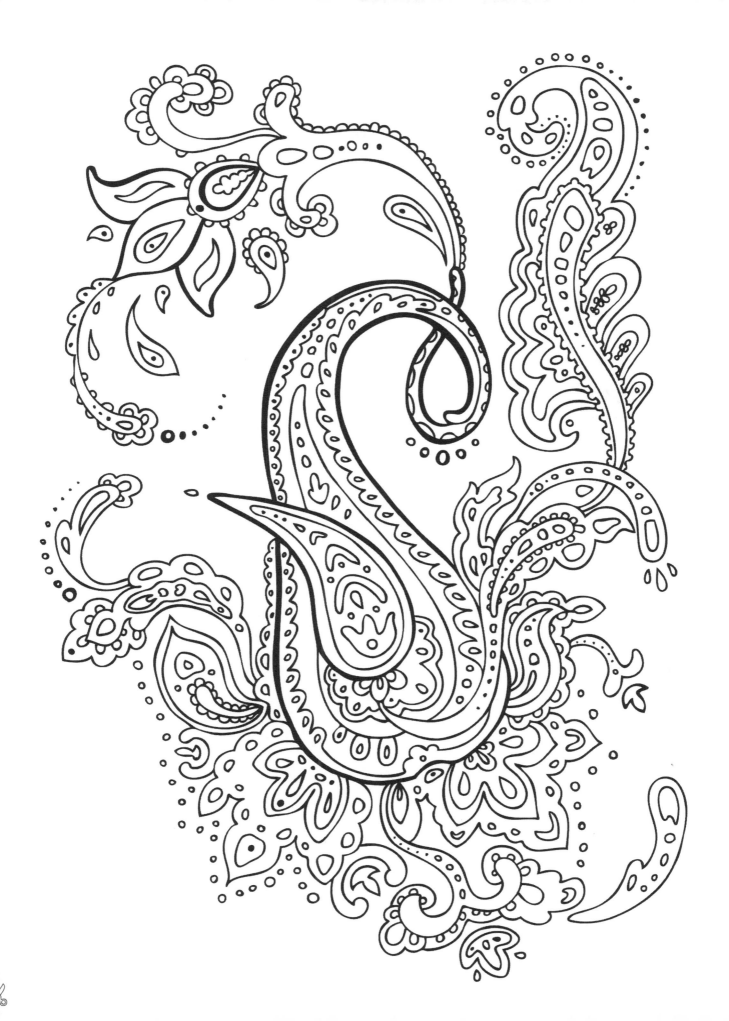

The future belongs to those who believe in the beauty of their dreams.

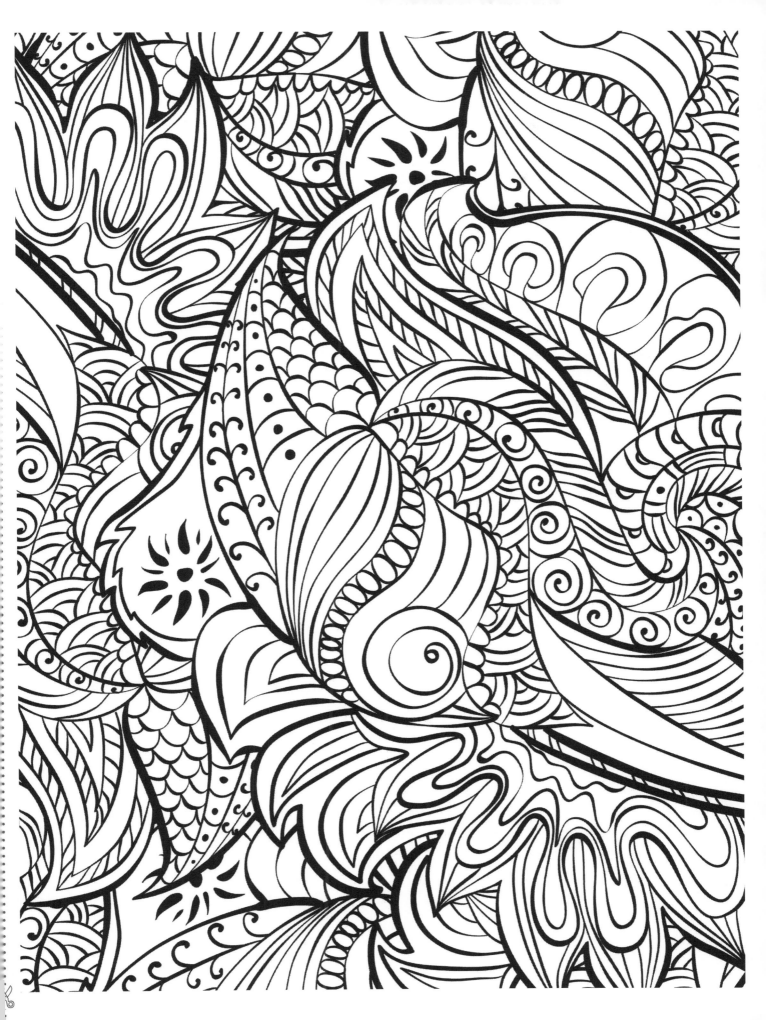

To accomplish great things, we must not only act, but also dream; not only plan, but also believe.

Anatole France

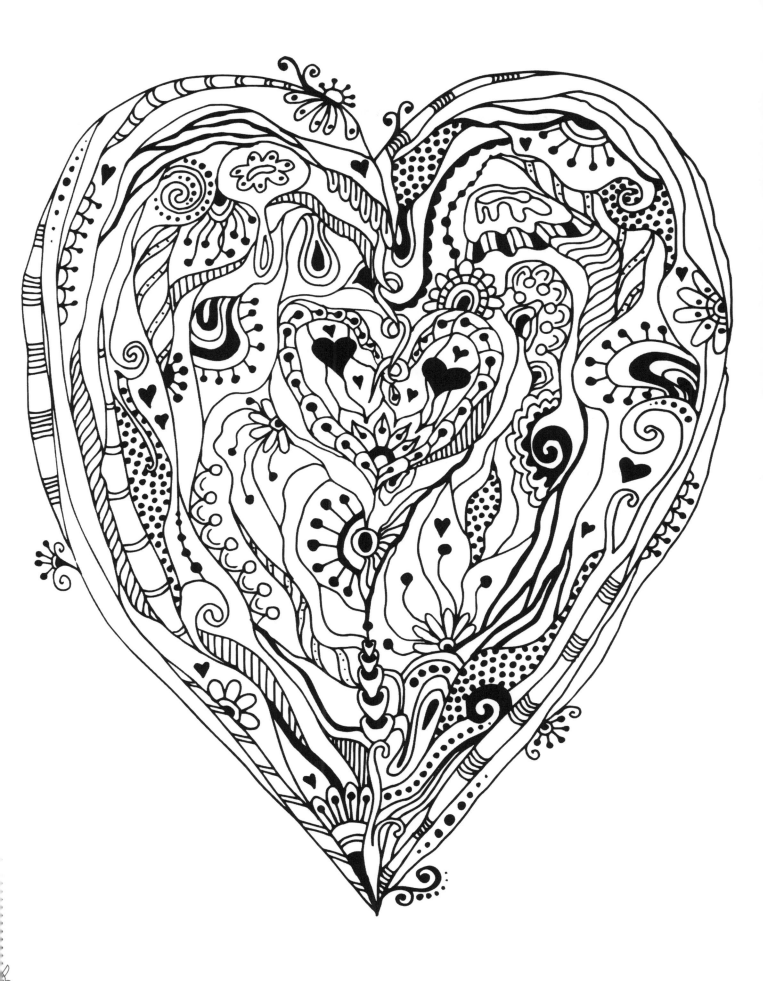

All men dream, but not equally. Those who dream by night in the dusty recesses of their minds, wake in the day to find that it was vanity: but the dreamers of the day are dangerous men, for they may act on their dreams with open eyes, to make them possible.

T. E. Lawrence

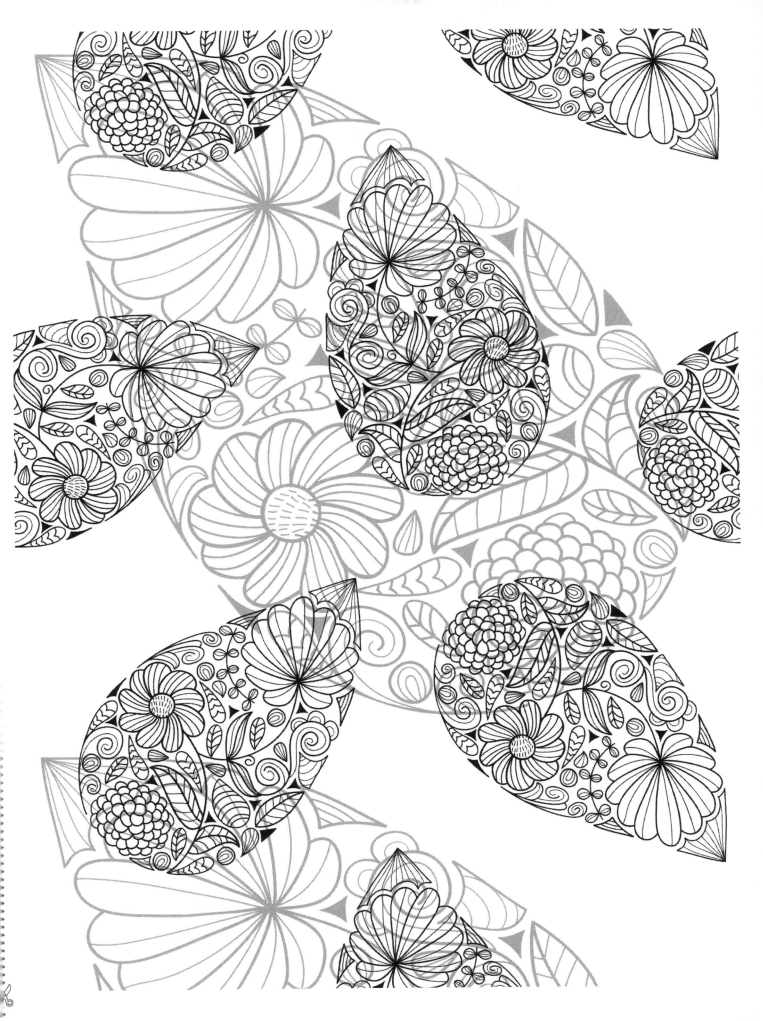

Hold fast to dreams, for if dreams die, life is a broken-winged bird that cannot fly.

Langston Hughe

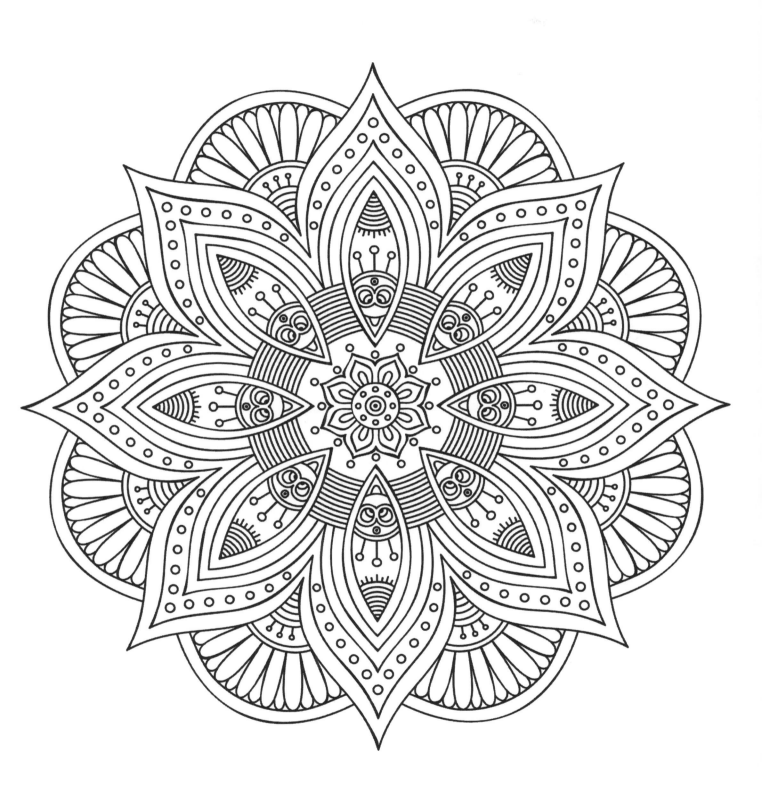

D

Dream as if you'll live forever. Live as if you'll die today.

James Dea

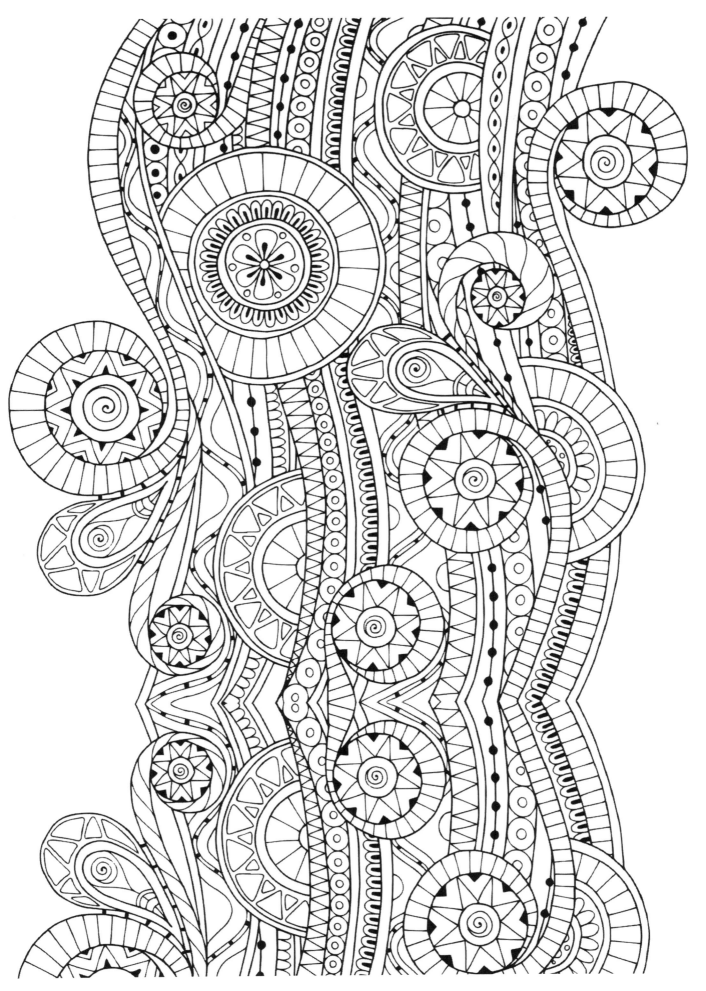

Great dreams of great dreamers are always transcended.

A. P. J. Abdul Kalam

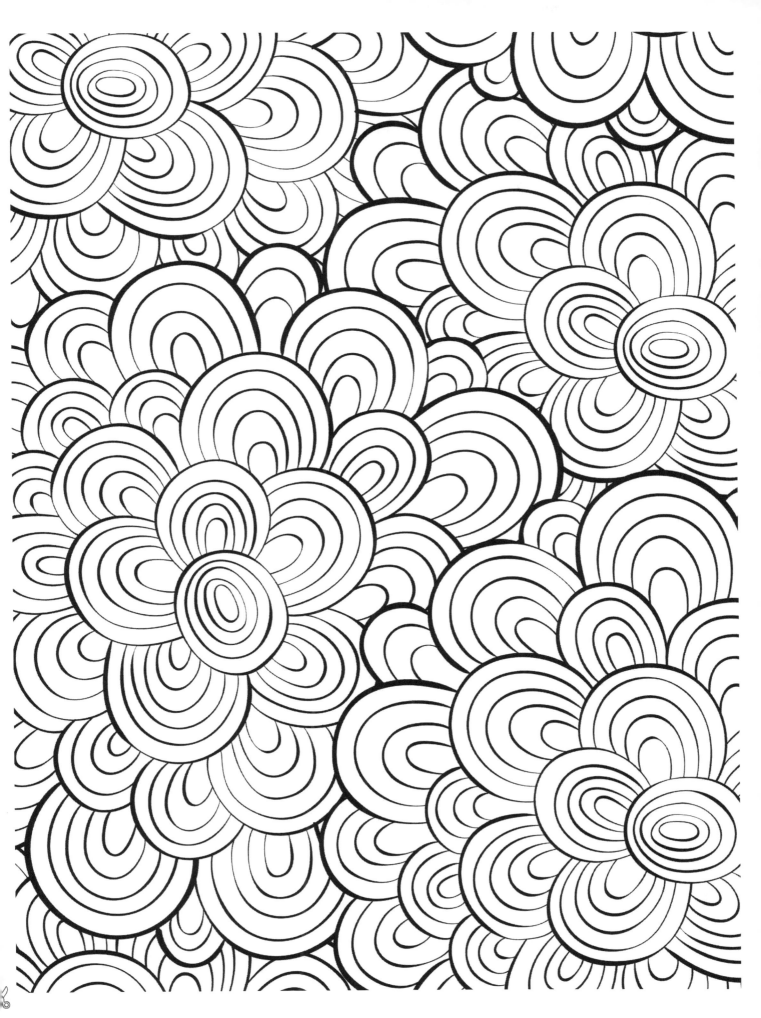

A dreamer is one who can only find his way by moonlight, and his punishment is that he sees the dawn before the rest of the world.

Oscar Wild

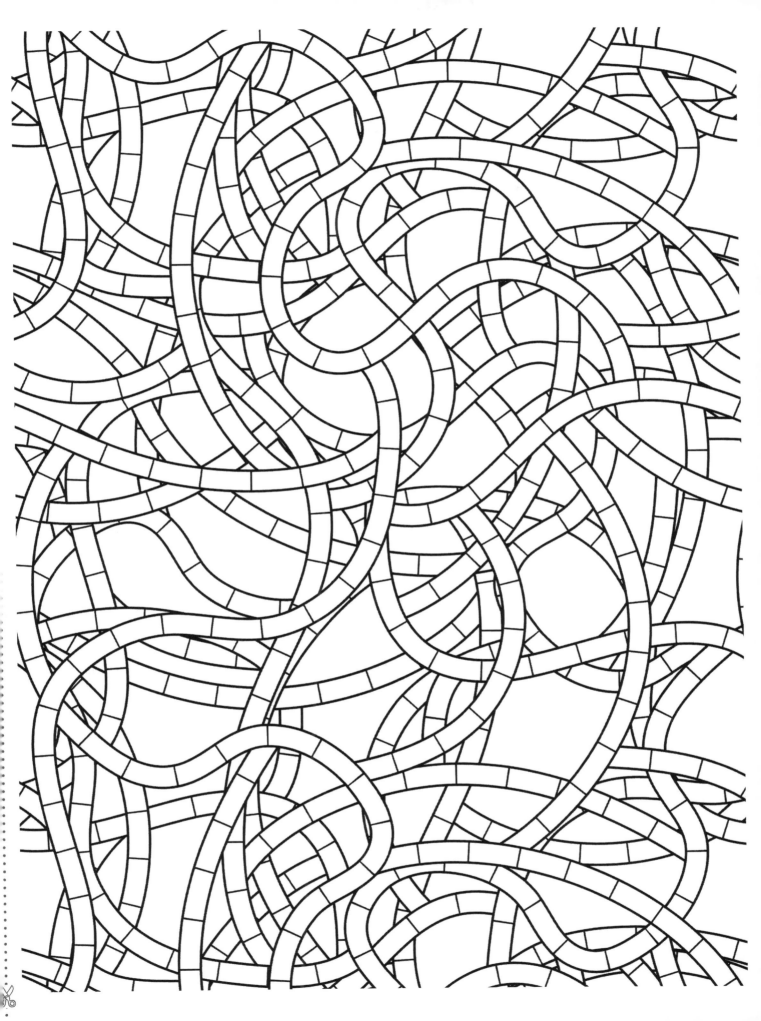

Sleep is the best meditation.

Dalai Lama

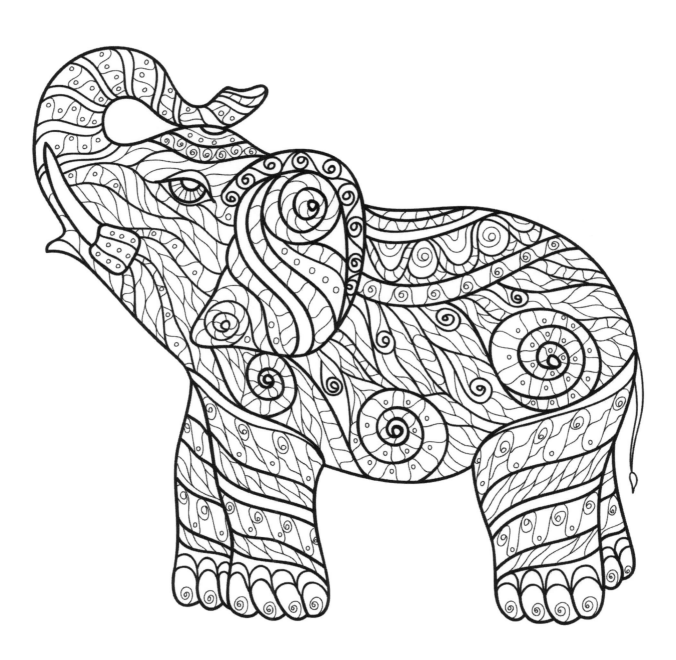

Yesterday is but today's memory,
and tomorrow is today's dream.

Khalil Gibran

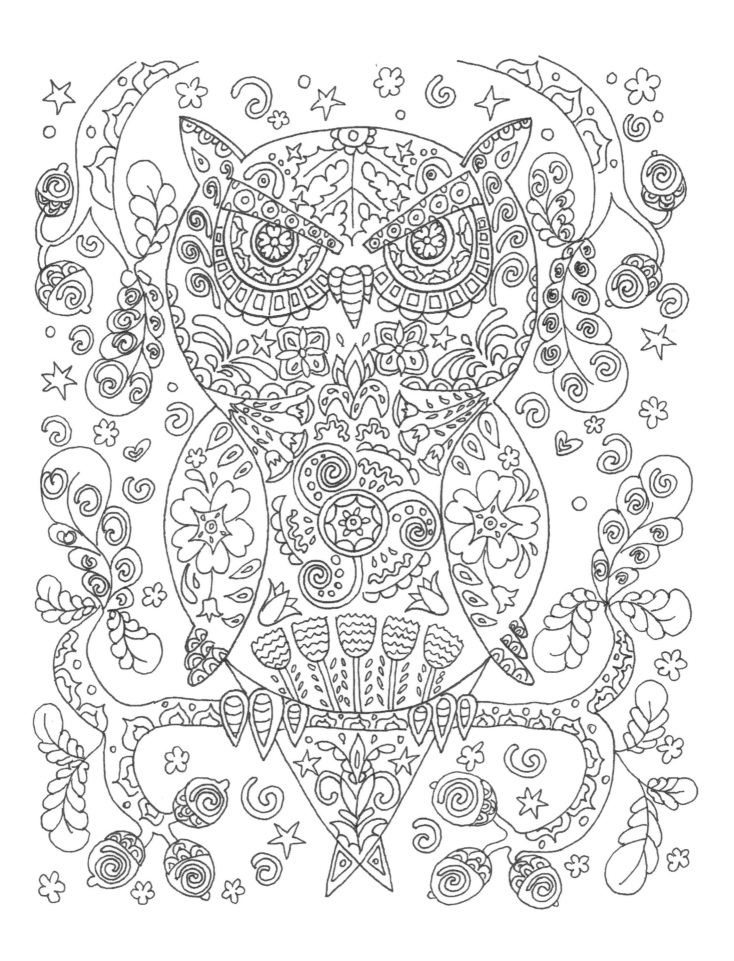

If one advances confidently in the direction of his dreams, and endeavors to live the life which he has imagined, he will meet with a success unexpected in common hours.

Henry David Thoreau

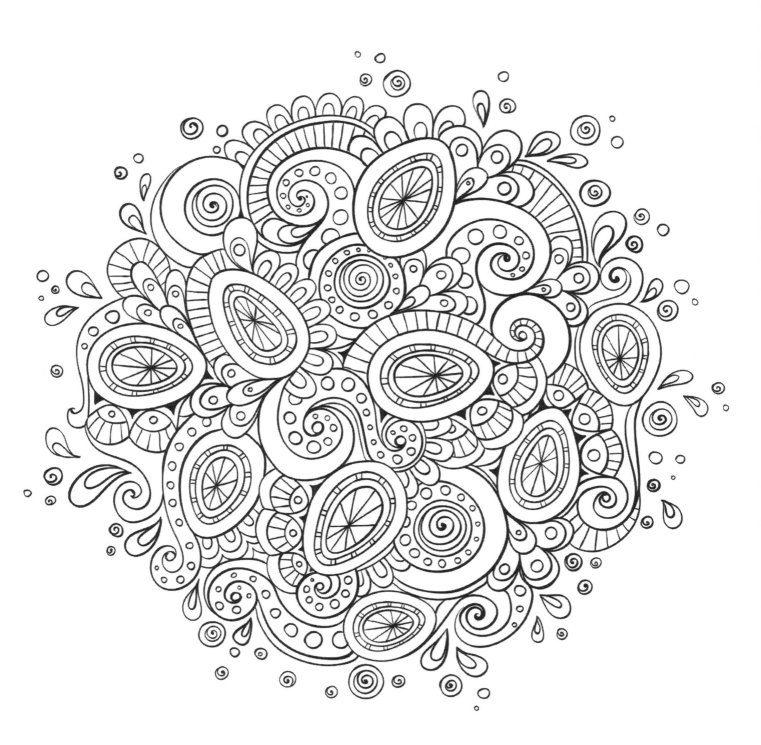

There are those who look at things the way they are, and ask why... I dream of things that never were, and ask why not?

Robert Kenned

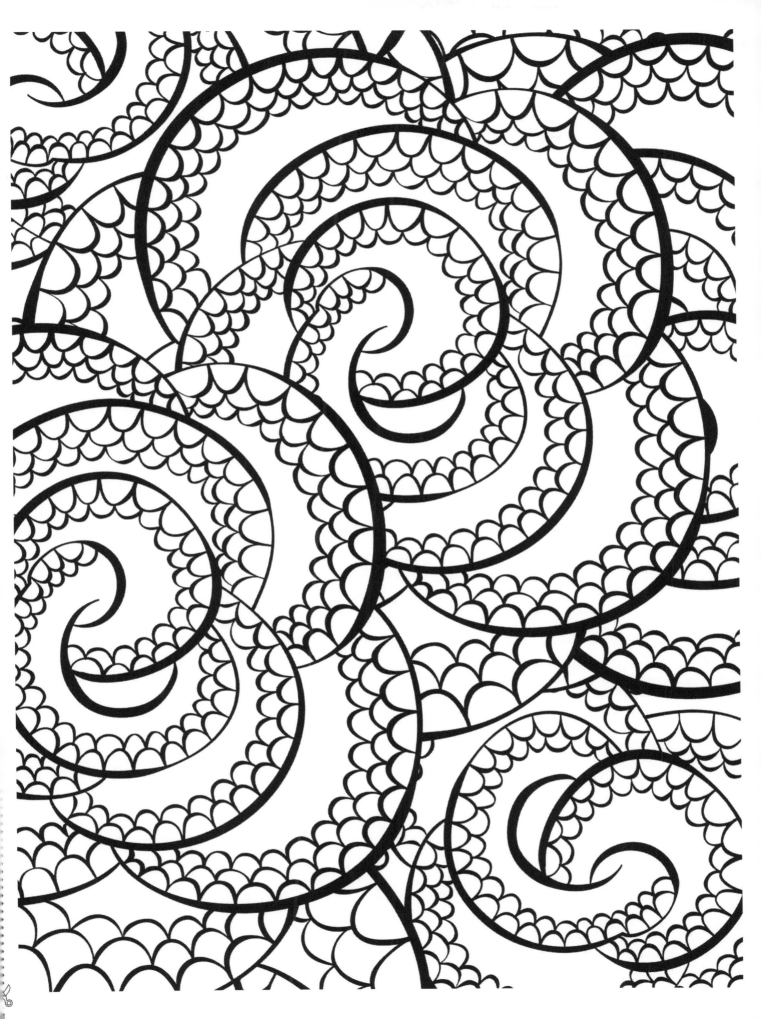

The interpretation of dreams is the royal road to a knowledge of the unconscious activities of the mind.

Sigmund Freud

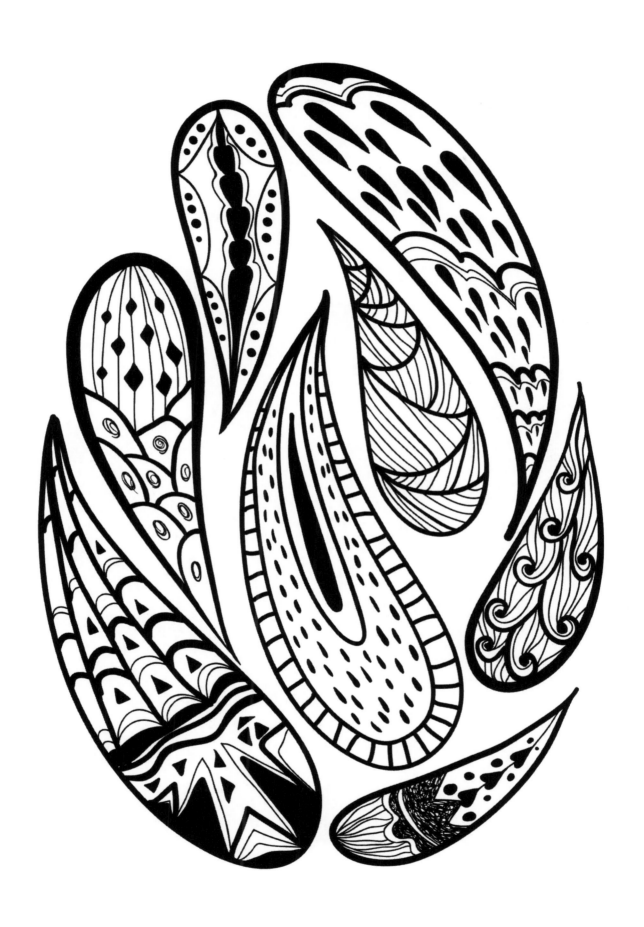

Who looks outside, dreams; who looks inside, awakes.

Carl Jung

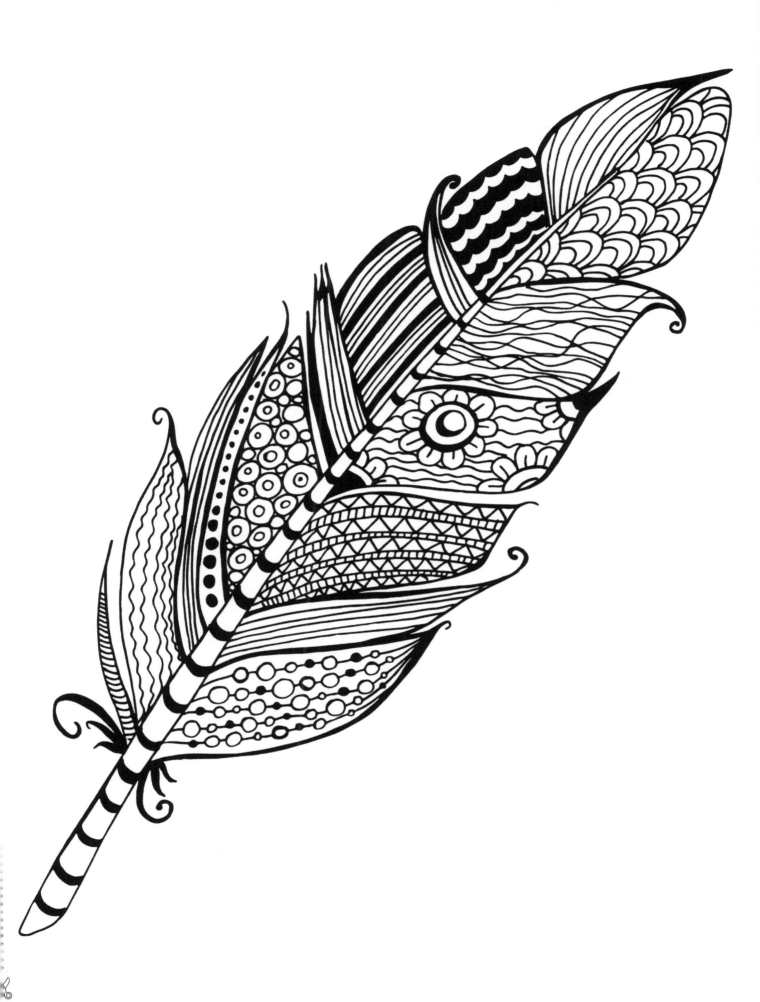

Without leaps of imagination, or dreaming, we lose the excitement of possibilities. Dreaming, after all, is a form of planning.

Gloria Steiner

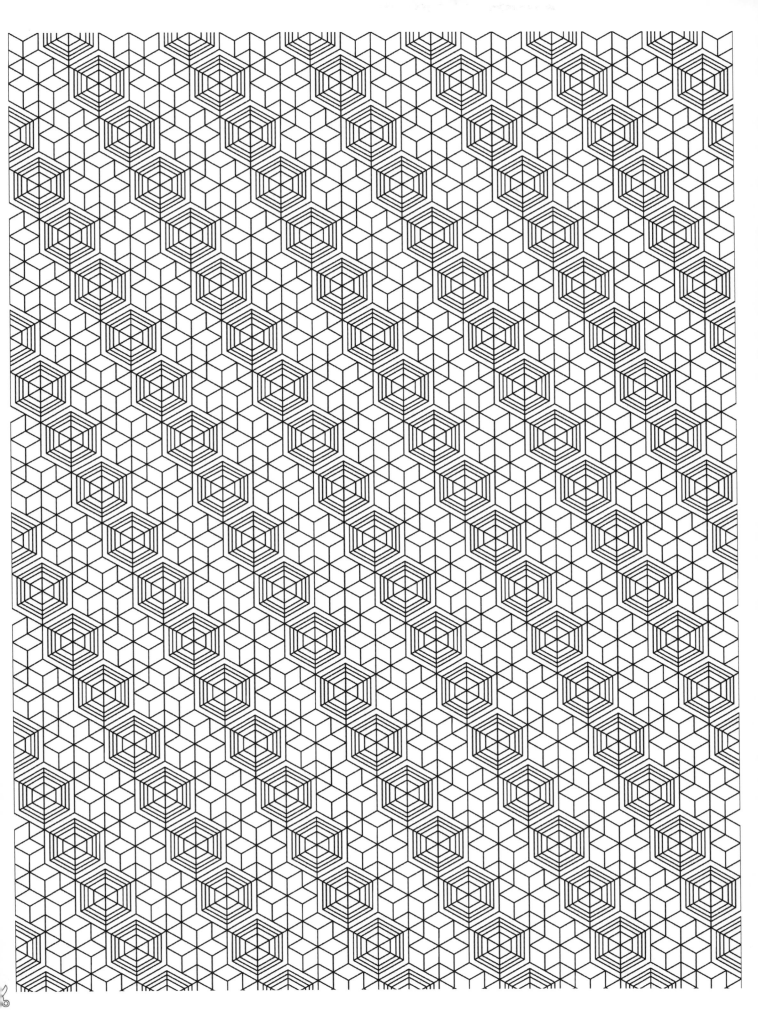

D
ream no small dreams for they have no power to move the hearts of men.

Johann Wolfgang von Goethe

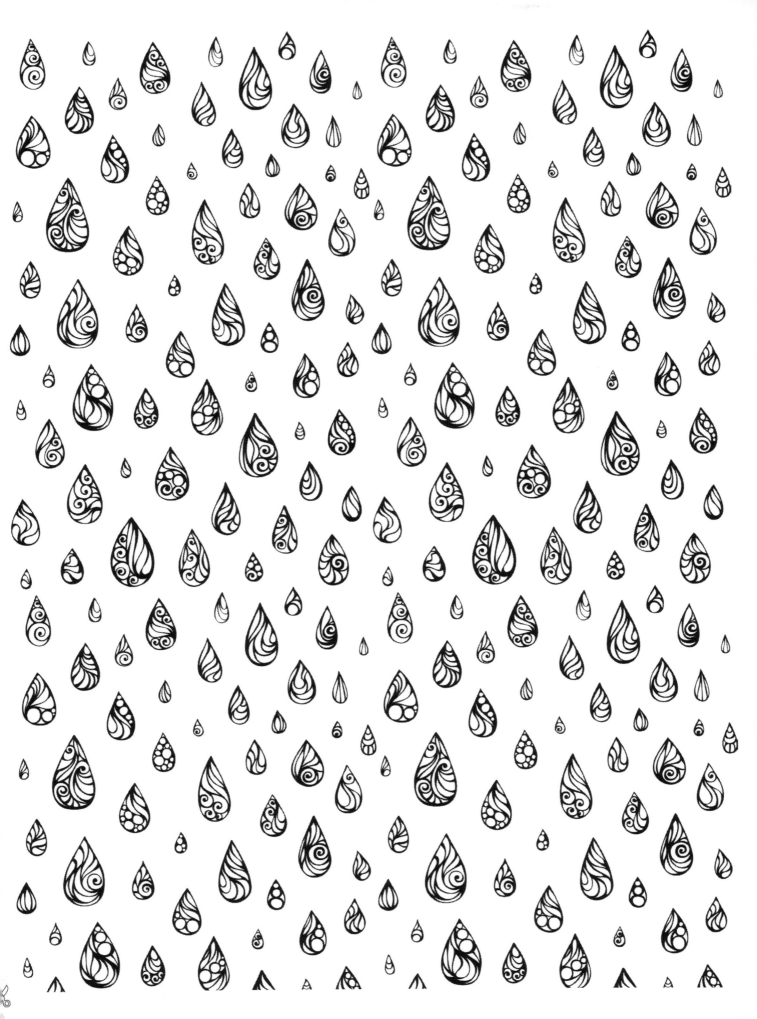

Happiness depends on what you can give, not on what you can get.

Swami Chinmayanand

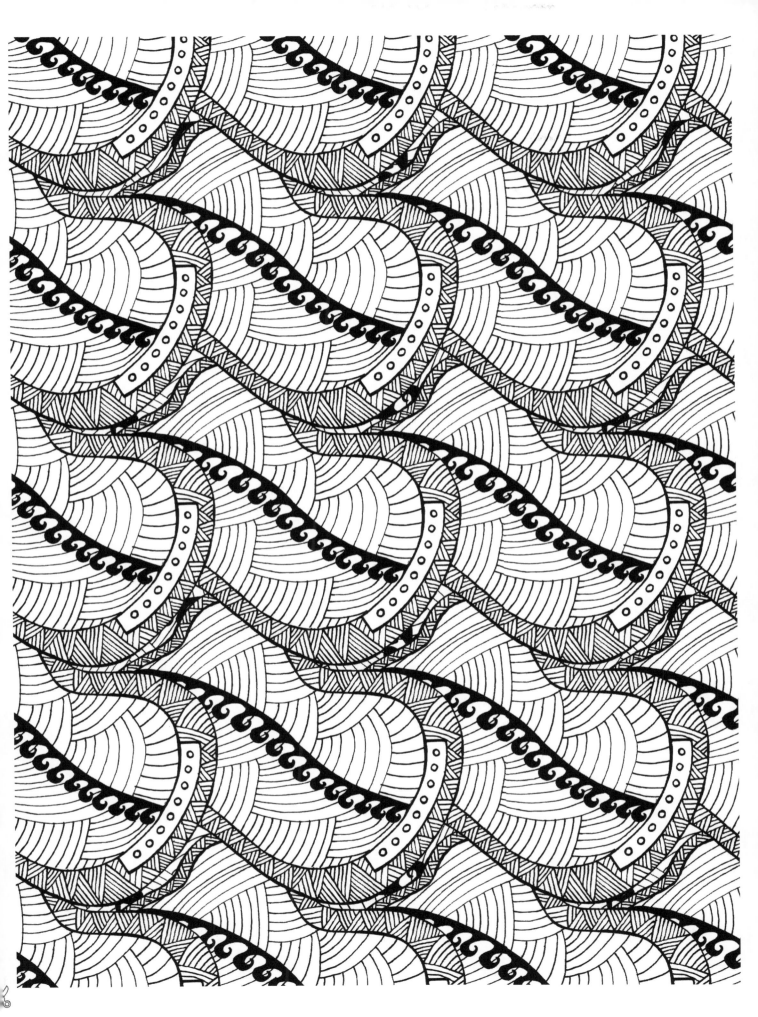

We have not come here to take prisoners, but to surrender ever more deeply to freedom and joy.

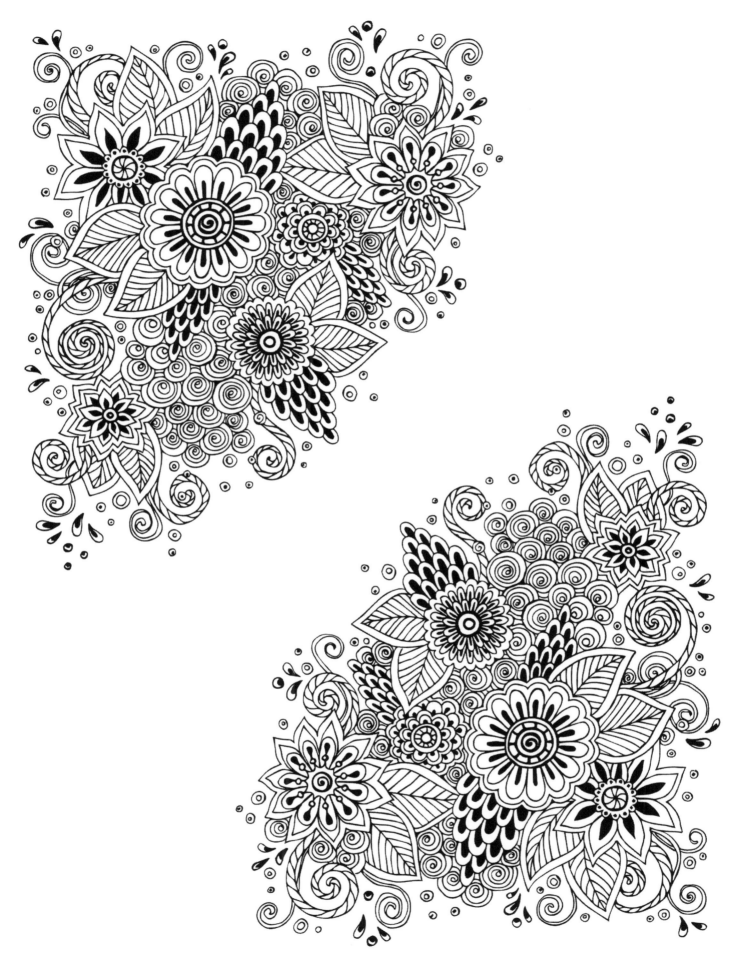

It is a puzzling thing. The truth knocks on the door and you say, "Go away, I'm looking for the truth"... and so it goes away. Puzzling.

Robert M. Pirsi

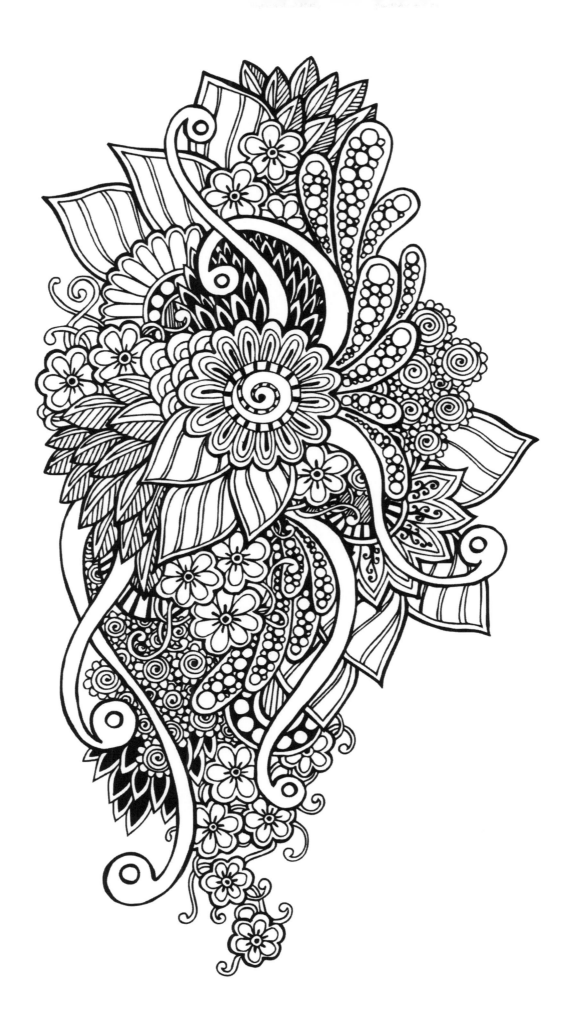

It took me forty years on earth
to reach this sure conclusion:
there is no Heaven but clarity,
no Hell except confusion.

Jan Struthe

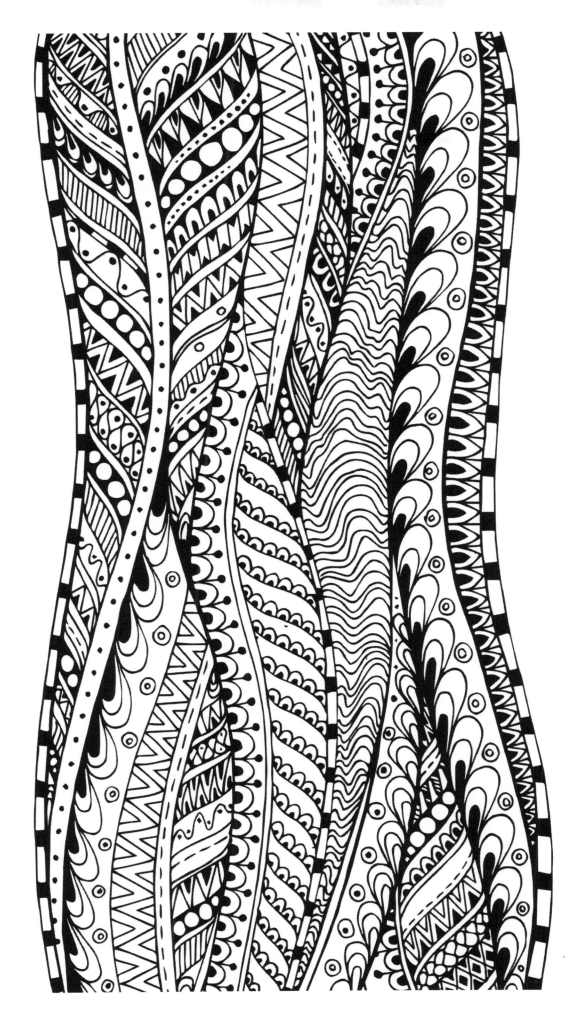

I do not ask to see,
I do not ask to know,
I ask only to be used.

Author Unknow

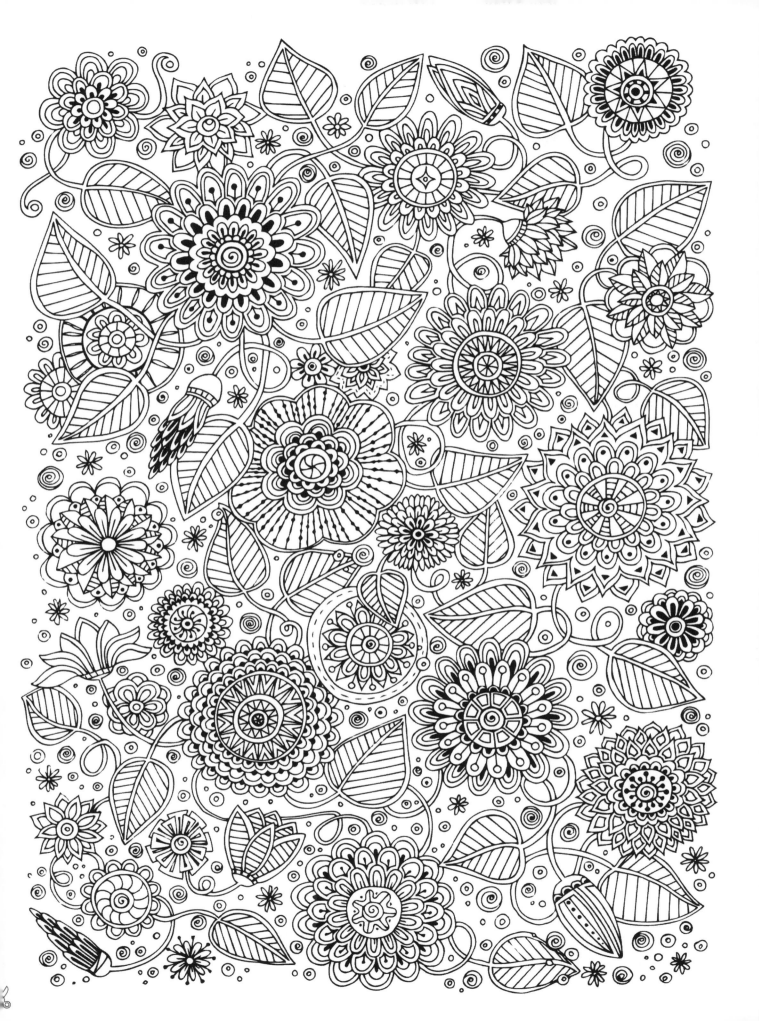

12657517R00038

Printed in Poland
by Amazon Fulfillment
Poland Sp. z o.o., Wrocław